TO OUR GIRLS FROM CRANSTON, RHODE ISLAND.

Amy, Tara, Robin, Julie, Tina, Beth, Cheryl, and Hilary.

Dearest friends 'til the end.

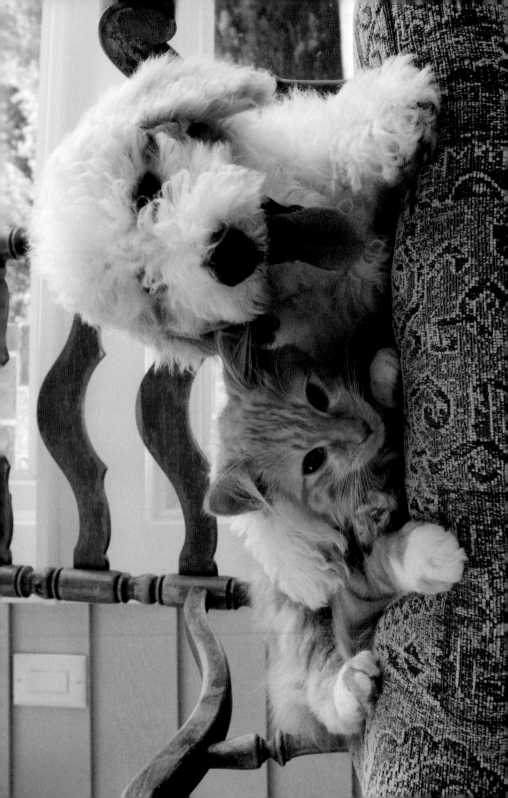

Frenemies

Cats, Dogs, and Lessons in Getting Along

Photographs by **KIM LEVIN**

Written by **CHRISTINE MONTAQUILA**

STEWART, TABORI & CHANG · NEW YORK

Published in 2009 by Stewart, Tabori & Chang
An imprint of Harry N. Abrams, Inc.

Editor: Dervla Kelly
Designer: Susi Oberhelman
Production Manager: Tina Cameron

ISBN: 978-1-58479-753-1

The text of this book was composed in Seria Sans and Zephyr.

Printed and bound in China

10 9 8 7 6 5 4 3 2 1

HNA ▮▮▮▮
harry n. abrams, inc.
a subsidiary of La Martinière Groupe

115 West 18th Street
New York, NY 10011
www.hnabooks.com

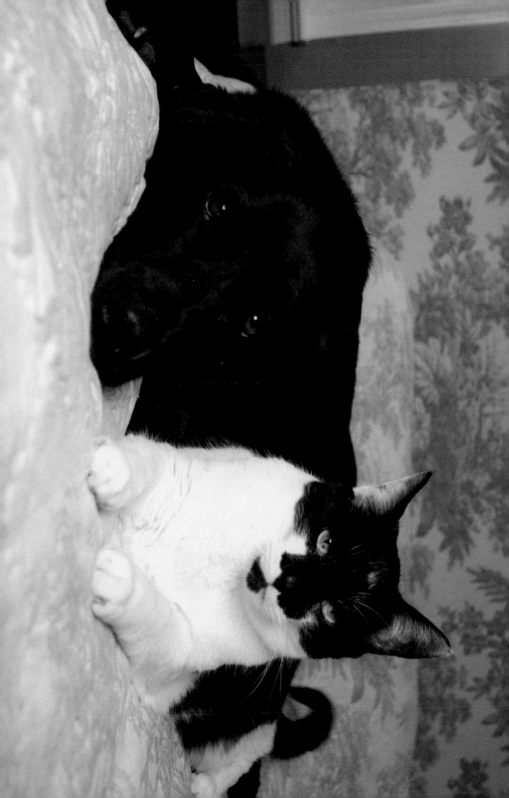

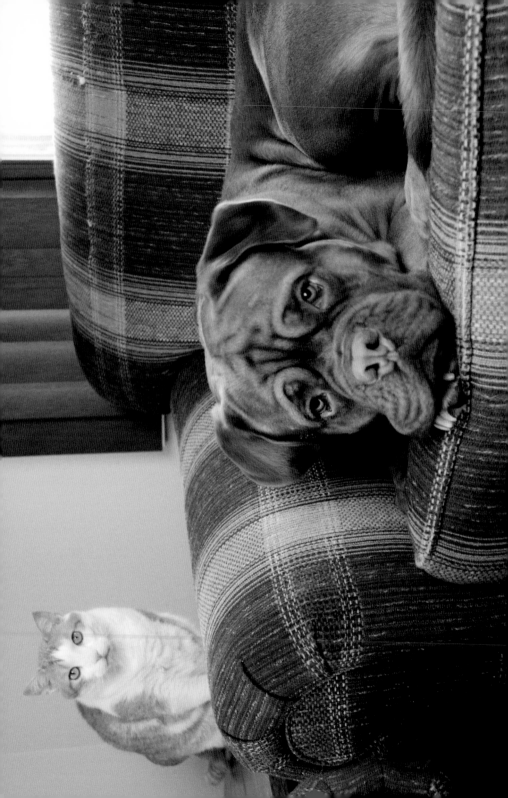

Realize you can't change someone,
but you can change your phone number.

BEANS & PORK CHOP

Spread love not bacteria.

 PERCY & HARLEY

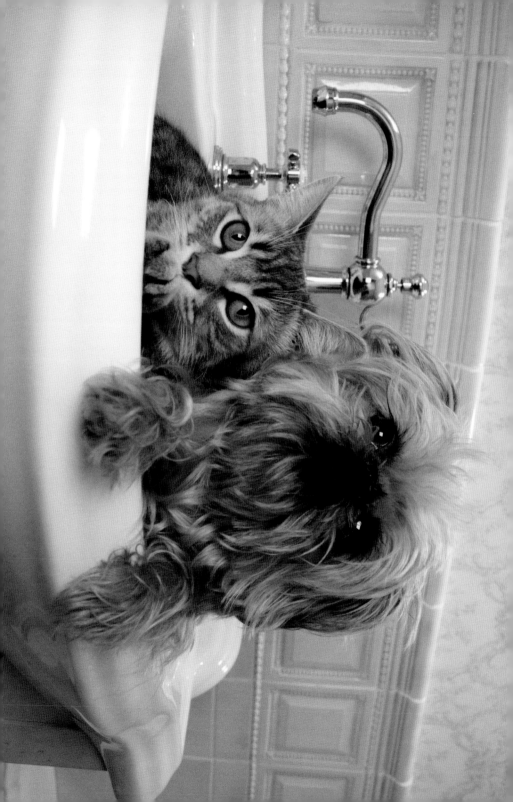

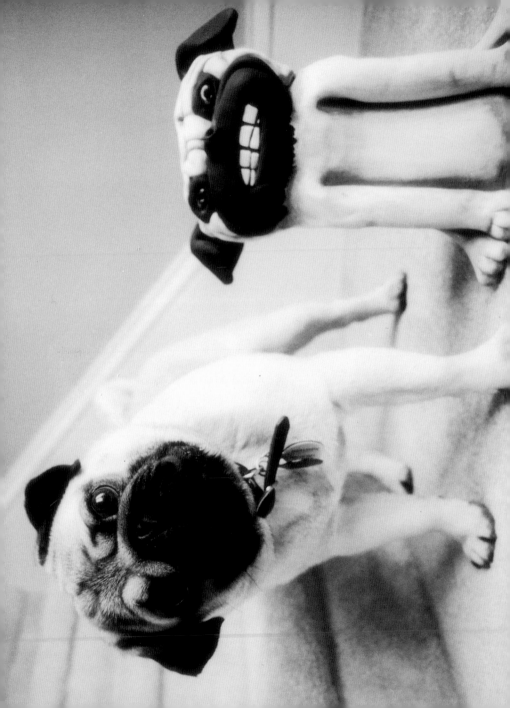

Know how to spot a phony.

STEWIE & STATUE

What you can't say with words, say with a snuggle.

— NINA & KITTEN

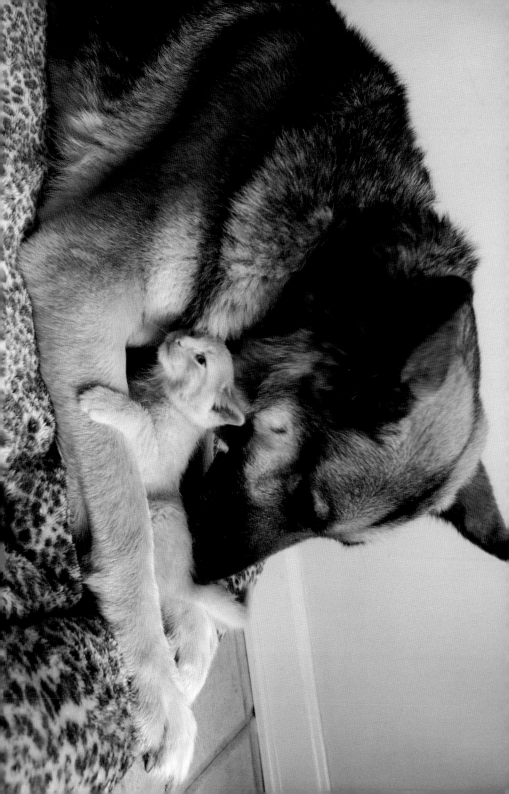

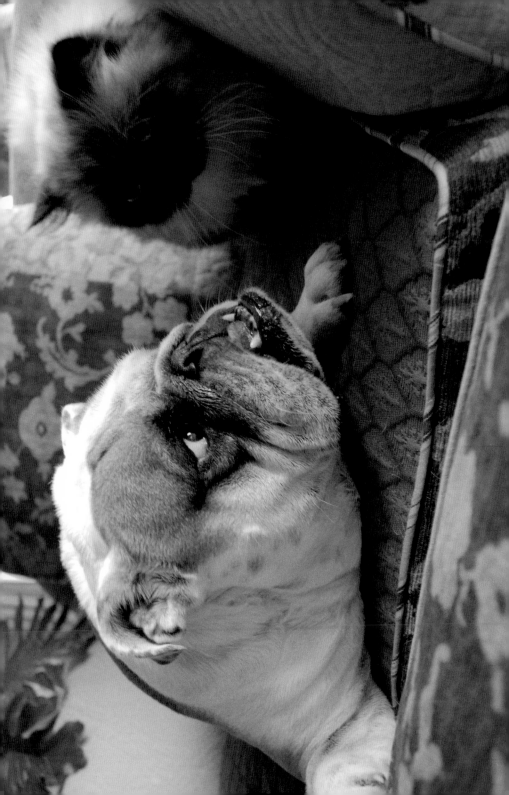

Don't negotiate with terrorists or toddlers.

SPIKE & SEBASTIAN

Know when to stop being a friend and start being a stylist.

 BUCKLEY & SAMPSON

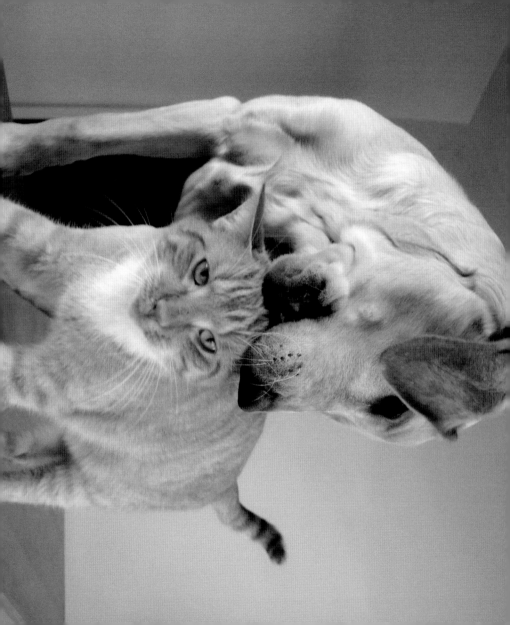

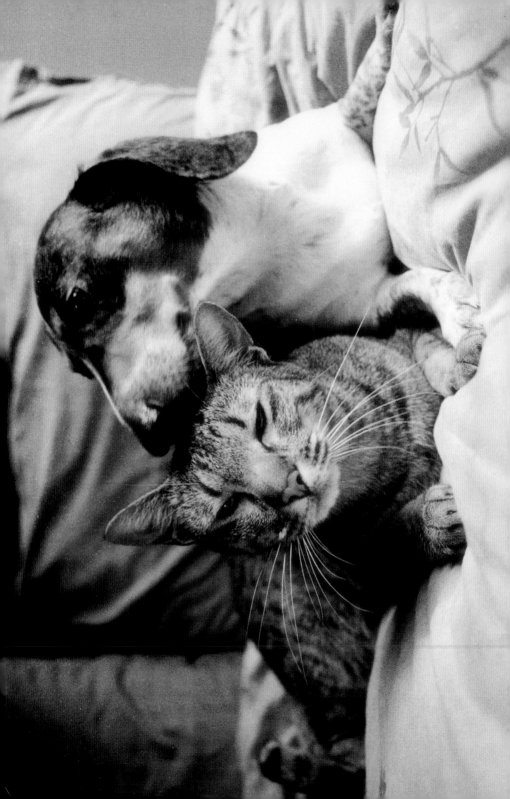

Never text an apology.

OZZIE & WILBUR

Don't judge an alternative lifestyle.

OLIVER & FONZI

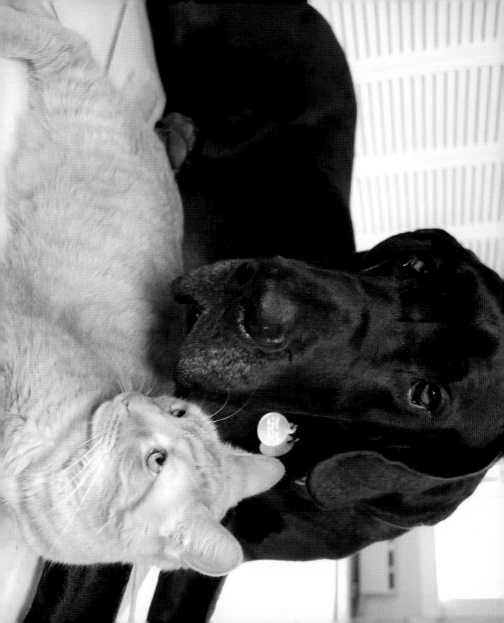

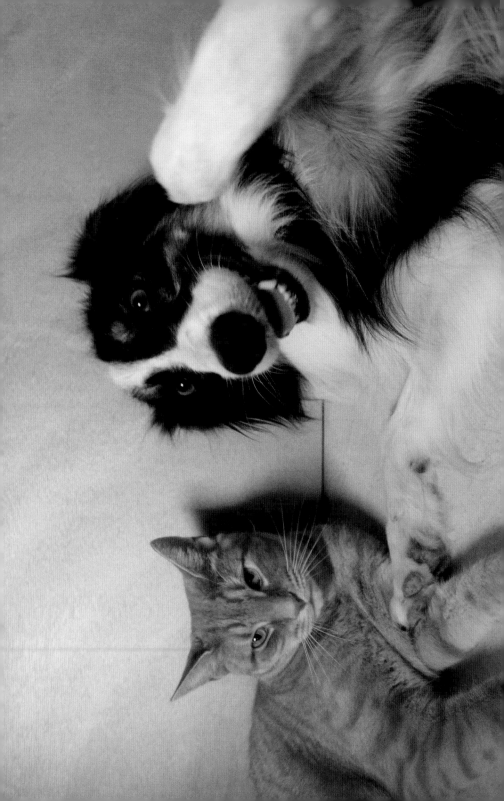

Give lunatics and relatives a second chance.

GOATY & FURY

Remember your friend's birthday, but forget their age.

LOKI & MOXIE

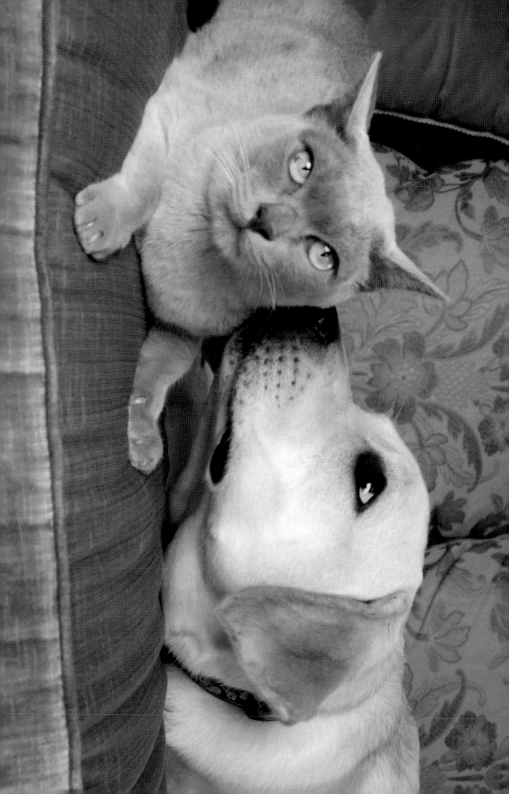

Avoid being a complainaholic.

DEMI & MOLLY

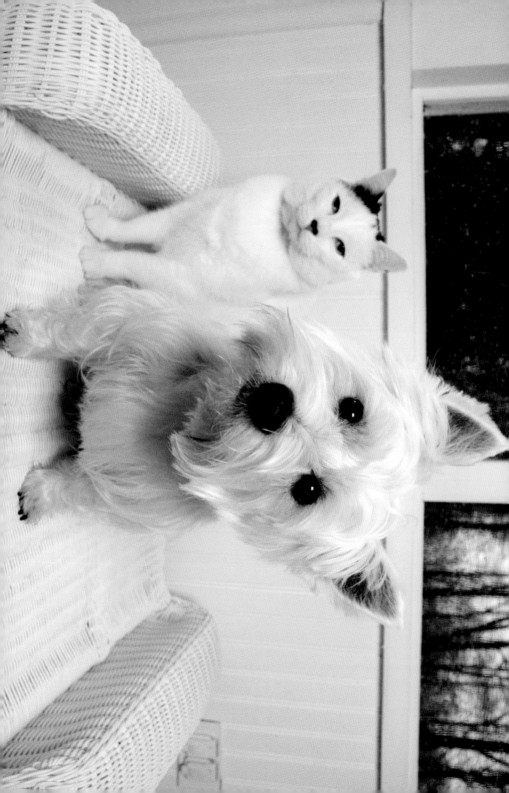

Steer clear
of the
love triangle.

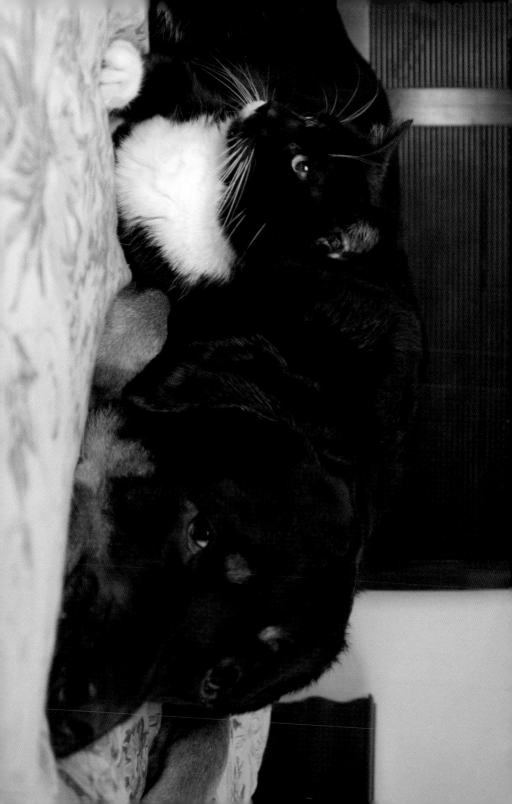

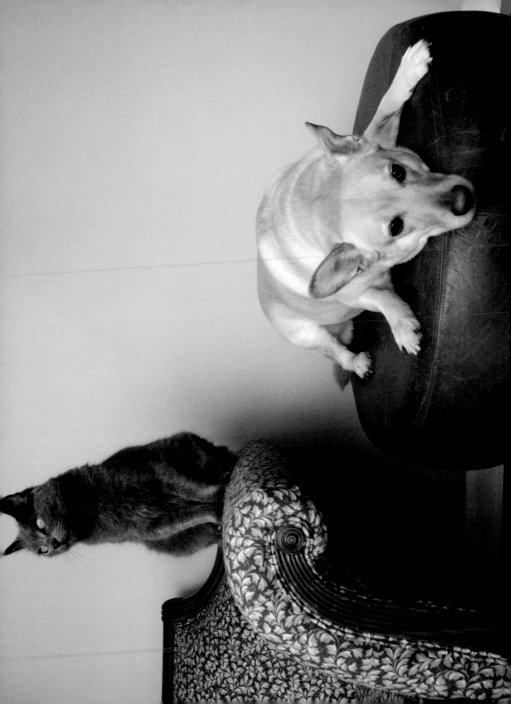

Be on call for emergencies and breakups.

MOO & OCEAN

Only count your own calories.

SLY & SALTY

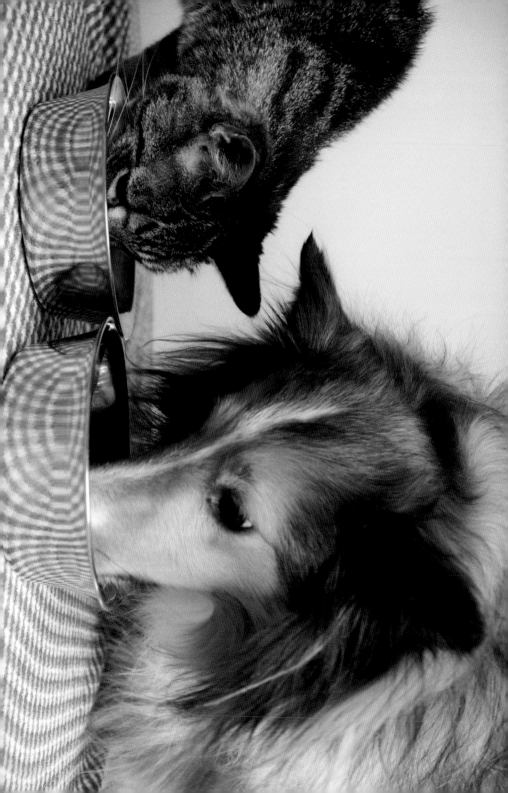

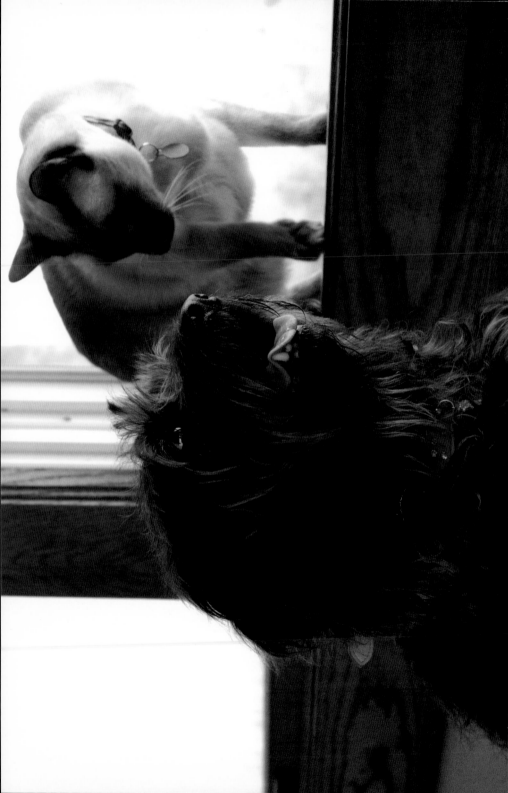

Avoid discussing politics, religion, and your goal weight.

MORGAN & PYE

Bitch slap only as a last resort.

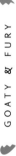

GOATY & FURY

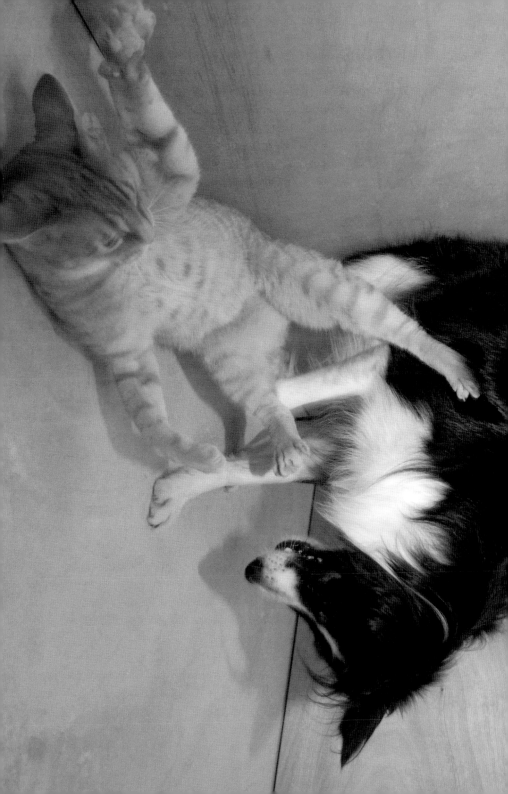

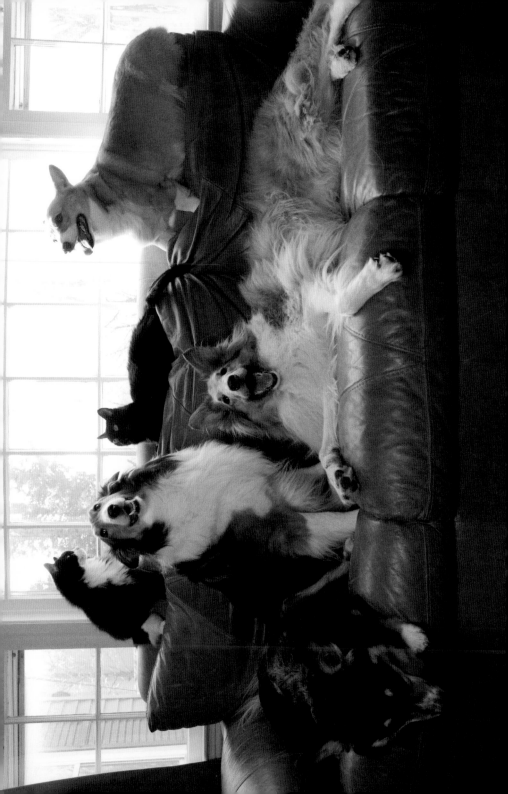

Invite everyone, but pray not everyone shows up.

STELLA, OREO, SHELLY, SPIDER, ROCKY & MAX

Offer to drive the getaway car.

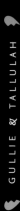

GULLIE & TALLULAH

Clean up your emotional messes.

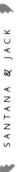

SANTANA & JACK

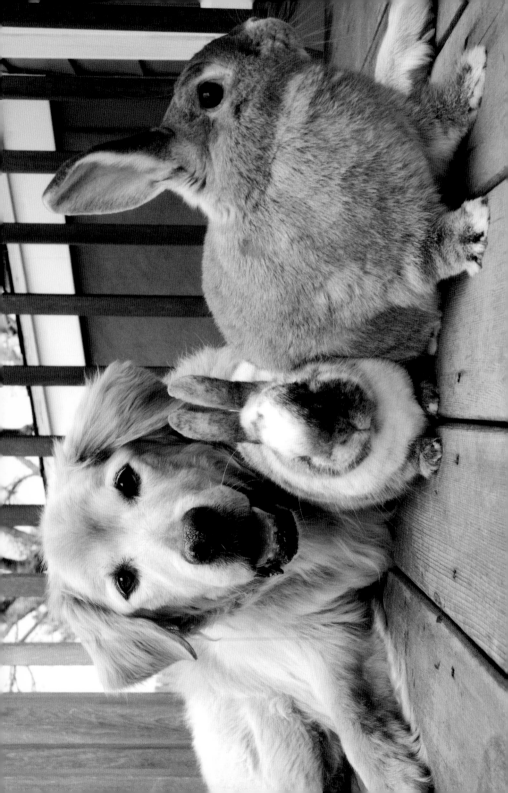

Treat friends like your fantasy family.

ALO, BREYER & SOPHIE

Search high and low for common ground.

LADY & SEDONA

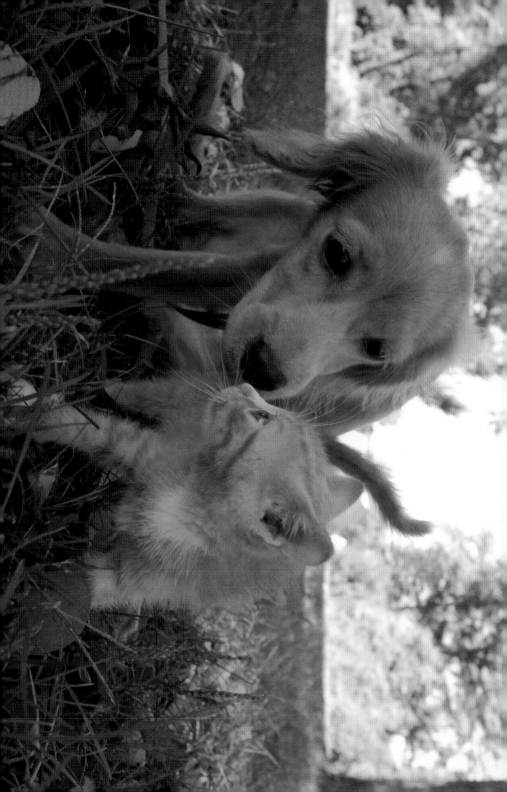

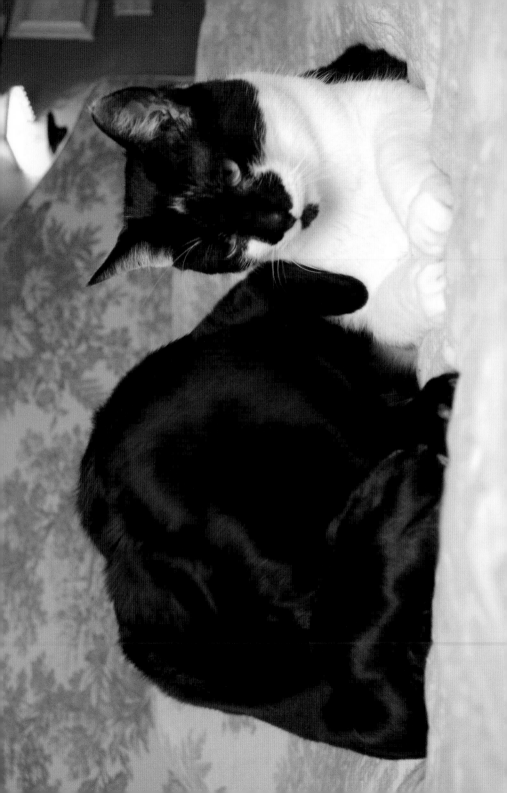

Learn the *twelve* steps of *shutting up.*

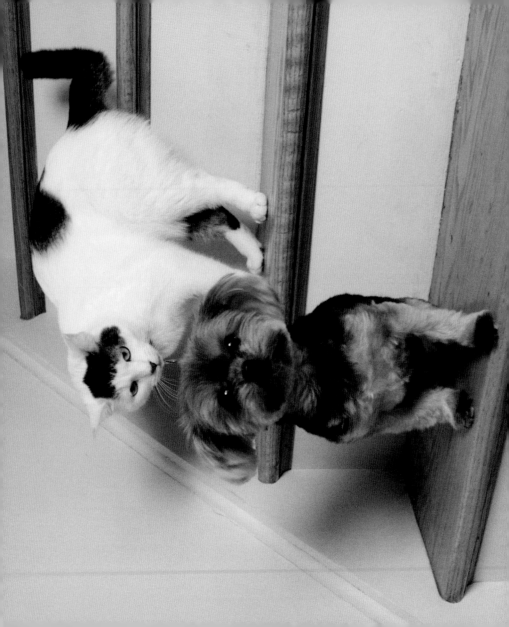

Know when a superiority complex is necessary for survival.

ANGEL & SIMON

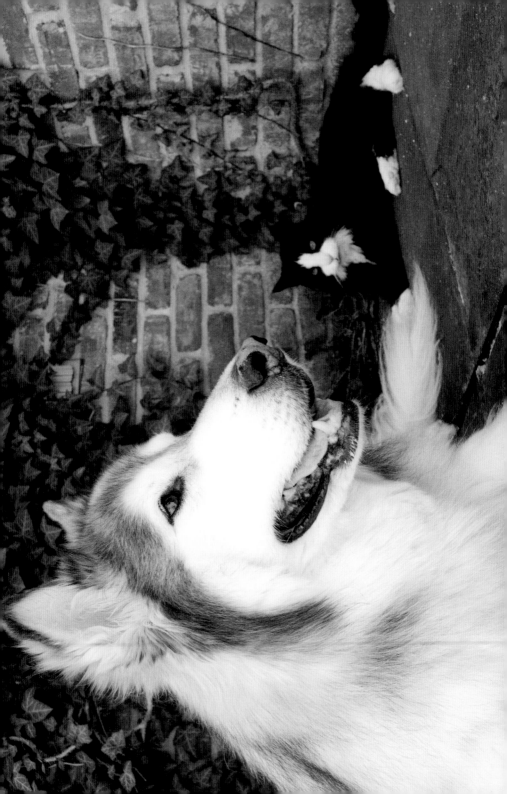

Never sue a next door neighbor.

LITTLE BEAR & BYTIE

Return everything you steal.

 BUCKY & TIDUS

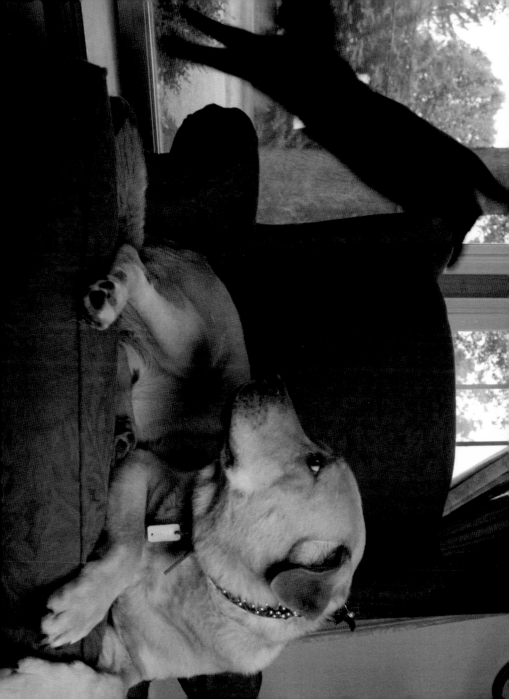

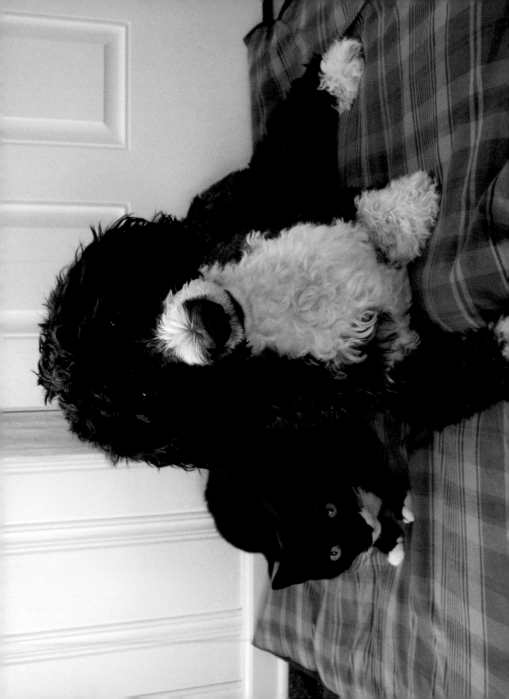

Hire professional movers.

CLYDE & GRIFFEN

Treat others with *love*, understanding and when necessary, drugs.

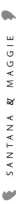 SANTANA & MAGGIE

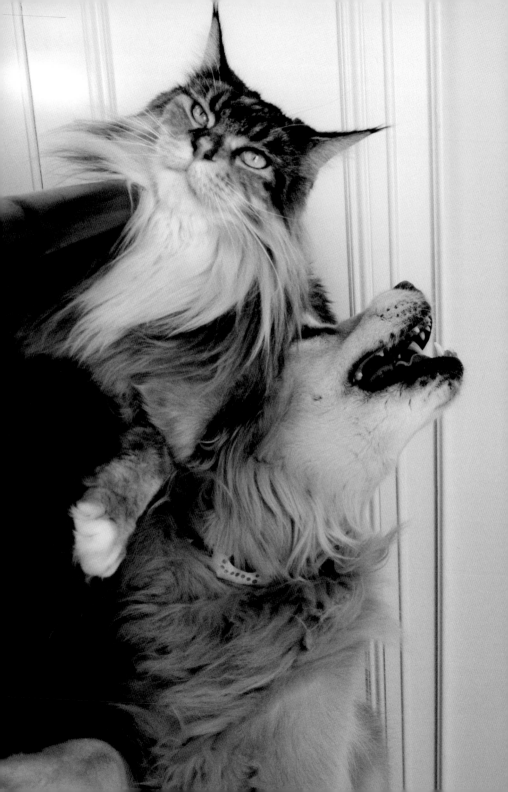

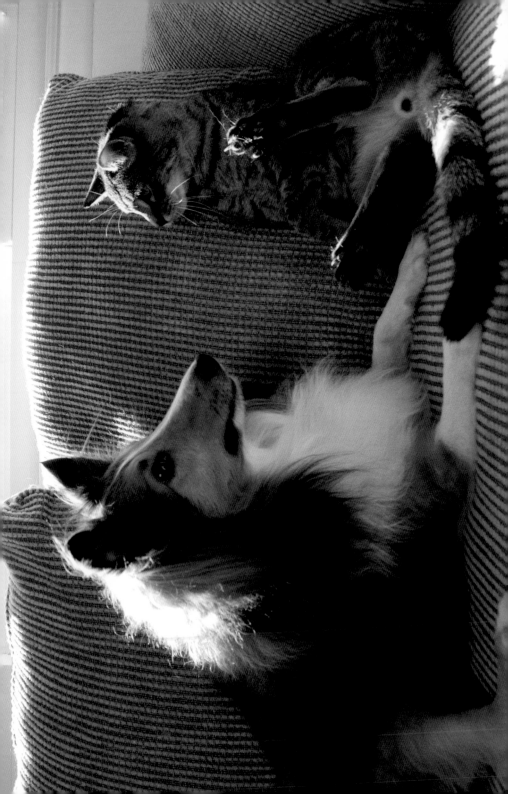

Keep your gossip about celebrities.

SALTY & SLY

Acknowledgments

Many thanks to Dervla and the team at STC for your continued support of our series. To Rick for your stellar advice. To all the cat and dog owners for allowing us to photograph your best friends. And to our families, for your love, support, and shameless PR.

About the Authors

By day, CHRISTINE MONTAQUILA is a freelance writer and co-creator of Naughty Betty, a greeting card and gift company for modern women. She lives outside Chicago with her husband, three children, Luca, Francesca, and Leo, and their gray tiger cat Maddie. Visit her at www.naughtybettyinc.com.

KIM LEVIN has published 17 books including the best-selling Cattitude and Why We Love Dogs. Her other pet portrait books include PhoDOGraphy, Pawfiles, Caternal Instincts, Catrimony, Hounds for the Holidays, Why We Love Cats, Growing Up, Dogma, and Working Dogs. Her company Bark & Smile Pet Portraits combines her passion for photography and her love of animals. An advocate of animal adoption, Kim has been donating her photography services for many years. Kim lives in New Jersey, with her husband, two children, Ian and Rachael, and their dog Charlie. You can view her work at www.kimlevin.com.

For more work by Kim and Christine, including their line of pet themed greeting cards called Molly & Fig, visit www.mollyandfig.com.